Sister Wendy's
IMPRESSIONIST
Masterpieces

SISTER WENDY'S
IMPRESSIONIST
MASTERPIECES

SISTER WENDY BECKETT
CONTRIBUTING CONSULTANT PATRICIA WRIGHT

DK PUBLISHING, INC.
New York
www.dk.com

Dorling DK Kindersley

LONDON, NEW YORK, SYDNEY, DELHI, PARIS, MUNICH, and JOHANNESBURG

Senior editor Louise Candlish
Senior art editor Heather M^cCarry
Editor Susannah Steel
Art editor Claire Legemah
US editor Barbara Minton
Senior managing editor Anna Kruger
Managing editor Steve Knowlden
Deputy art director Tina Vaughan
Production controller Sarah Coltman
Picture researcher Marianna Sonnenberg

I would like to dedicate this book to Tricia Wright, without whose support, research, insights, and inspiration, it would never have been begun; let alone finished. Thank you dear Tricia, invaluable friend.

First American Edition, 2000
00 01 02 03 04 05 10 9 8 7 6 5 4 3 2 1

Published in the United States by Dorling Kindersley Publishing, Inc.
95 Madison Avenue, New York, New York 10016

DK Publishing offers special discounts for bulk purchases for sales promotions or premiums. Specific, large-quantity needs can be met with special editions, including personalized covers, excerpts of existing guides, and corporate imprints. For more information, contact Special Markets Dept., DK Publishing, Inc., 95 Madison Ave., New York, NY 10016 Fax: 800-600-9098.

Library of Congress Cataloging-in-Publication Data

Beckett, Wendy.
 Sister Wendy's impressionist masterpieces / Sister Wendy Beckett. — 1st American ed.
 p. cm.
 Includes index.
 ISBN 0-7894-5958-7
 1. Impressionism (Art) 2. Painting, Modern--19th century. 3. Painting, Modern—20th century. 4. Art appreciation. I. Title: Impressionist masterpieces. II. Title.

ND192.I4 B43 2001
759.05'4—dc21

00-057071

Colour reproduced by GRB Editrice, Italy
Printed and bound by A.G.T., Spain
D.L. TO: 1764-2000

CONTENTS

BONNARD, PIERRE 1867–1947 b. France
NUDE IN BATHTUB

FACED WITH THE GLORY of a late Bonnard – drawn in and overwhelmed by the sheer wonder of the colors – we have to make an effort to withdraw enough to understand the motif. This is the most familiar of Bonnard's motifs: his wife Marthe in the bathtub. Theirs was a strange relationship. He lived with this neurotic and difficult woman for many years before they married, and although to his friends she was bad news, as it were, the relationship between them seemed to have been, artistically, intensely productive. Her need to immerse herself frequently in the bathtub drew from Bonnard a series of magnificent pictures, of which this is the last. Marthe never aged in Bonnard's imagination; she was always that slender, long-legged girl he found so enticing many years before. She has become subsumed into a strange, luminous world. Even the small dachshund on the bath mat is as magical and glittering as the strange lady herself.

BONNARD *makes no attempt to convince us that this is visually realistic. This, he appears to suggest, was what it felt like to be in an enclosed world of bright tiles and clear water, with every part of it reflecting the splendor of light and warmth. If Marthe is almost drowned in that reflective light, so too is the viewer.*

THIS IS A MAGICAL WORLD *of safety and brightness, where one can only live, as Marthe does, in a moment treasured and prolonged. This is not the world as it is, nor as it should be; it is the world of vision, lost and cherished. The bathroom in Bonnard's house was, in fact, white, and all this chromatic splendor comes from his mind.*

NUDE IN BATHTUB,
*c.1941–46, oil on canvas,
48 x 59 in (122 x 151 cm),
Museum of Art, Carnegie Institute, Pittsburgh*

THE ALMOND TREE IN BLOSSOM
1945–47, oil on canvas, 22 x 15 in (55 x 38 cm),
Musée National d'Art Moderne, Paris

❝ *As Bonnard's art matured,*
the colors he used became richer
and deeper, so that the whole
meaning is revealed in the color ❞

BONNARD, PIERRE

THE ALMOND
TREE IN BLOSSOM

THIS WAS BONNARD'S LAST PAINTING. It offers a world of stupendous color, evoking a sense of the warm sweetness of a French garden in spring rather than meticulously documenting it. On his deathbed, Bonnard asked his nephew to bring him this painting because he felt that the green on the lower left needed to be overlaid with yellow. His last act was to make that golden stroke, giving his picture the intellectually satisfying pattern that his mind, so orderly in its lyricism, always sought.

APPROACHING STORM,
1864, oil on wood,
15 x 23 in (37 x 58 cm),
The Art Institute of Chicago

THE GAIETY OF THE SCENE, *with its wonderful touches of red and its shimmer of activity, is, however, a threatened gaiety. These people are confronted by nature, but without understanding. Only the man gesturing to the skies has realized that it is time now to go home. Boudin is painting the beauty, both of the setting and of the human beings within it and, consequently, the significance of the contrast.*

BOUDIN, EUGÈNE 1824–98 b. France
APPROACHING STORM

BOUDIN WAS FASCINATED by the phenomenon of the middle class at play. These are not the peasants or the laborers, these are the wealthy shopkeepers, lawyers, doctors, and their families, who have come to enjoy themselves at the beach resort of Trouville on the Normandy coast. Boudin was criticized for vulgarizing his landscape with these arrays of expensive crinoline, but he insisted that the wealthy had an equal right to their day in the sun, pictorially. He was clearly very taken by the contrast of that great pool of sunlit sand, shadowed to one side, and the immensity of a burgeoning sky on the other – and between them, the long line of overdressed people. The artist is best known, perhaps, for his influence on Monet, who revered him and was encouraged by him, but a work like this shows that he has an importance in his own right.

Boudin, Eugène

THE BEACH AT TOURGÉVILLE-LES-SABLONS

As he grew older (this was painted five years before he died), Boudin became less interested in the visitors to the beach than in the setting itself. There are people here, walking on the sands with their sunshades and their pet dogs, but they are swallowed up in the austere beauty of the landscape. Two thirds of the picture is cloud-filled sky and the rest is the pallor of the sands, with a dash of green to suggest the countryside and a dash of the palest blue to suggest the sea. It is a picture of great silence.

THE BEACH AT
TOURGÉVILLE-LES-SABLONS
*1893, oil on canvas, 20 x 29 in
(51 x 74 cm), National Gallery, London*

CAILLEBOTTE, GUSTAVE 1848–94 b. France
RUE DE PARIS, WET WEATHER

CAILLEBOTTE IS AN ARTIST whom the social historians would have had to invent had he not already existed. This, his most famous work, represents what a sociologist would perhaps consider the correct subject matter for artists: the real, contemporary world in all its drabness and lack of romance. The Impressionists made token references to this, and in their paintings we see the occasional factory chimney or cityscape. But it was Caillebotte who, despite being more a well-to-do patron and hanger-on of the Impressionist scene, encapsulated the world of 19th-century Paris in this celebration of a wet street on a dull day. Without great visual excitement, it remains a picture of originality and beauty.

SUCH IS *Caillebotte's own fascination with what he sees that this painting has held viewers spellbound since its creation. It manages to convey a slice of life that – despite (or maybe because of) the lack of incident – makes us feel we have a measure of the pulse of late 19th-century Parisian life.*

CAILLEBOTTE *convinces us that this is what it was like on that particular afternoon in 1877, at a certain time of day, on a certain street in Paris, when the light was cool and bright, the streets were quiet, and the rain fell in a fine drizzle.*

RUE DE PARIS,
WET WEATHER
*1877, oil on canvas,
83 x 109 in (212 x 276 cm),
The Art Institute of Chicago*

CAILLEBOTTE, GUSTAVE
SELF-PORTRAIT

MOST OF CAILLEBOTTE'S WORK is stubbornly unromantic and clearly focused on the absolutely ordinary. It comes as a salutary surprise, therefore, to find that he himself had the appearance of the typical romantic artist. Here are the brooding eyes, the anguished lips, the sunken cheeks – the full gamut of the artist as creative genius – and, although one senses a subliminal touch of irony in his landscapes, there is none here. He looks at himself with utter seriousness.

SELF-PORTRAIT
1892, oil on canvas,
16 x 13 in (41 x 33 cm),
Musée d'Orsay, Paris

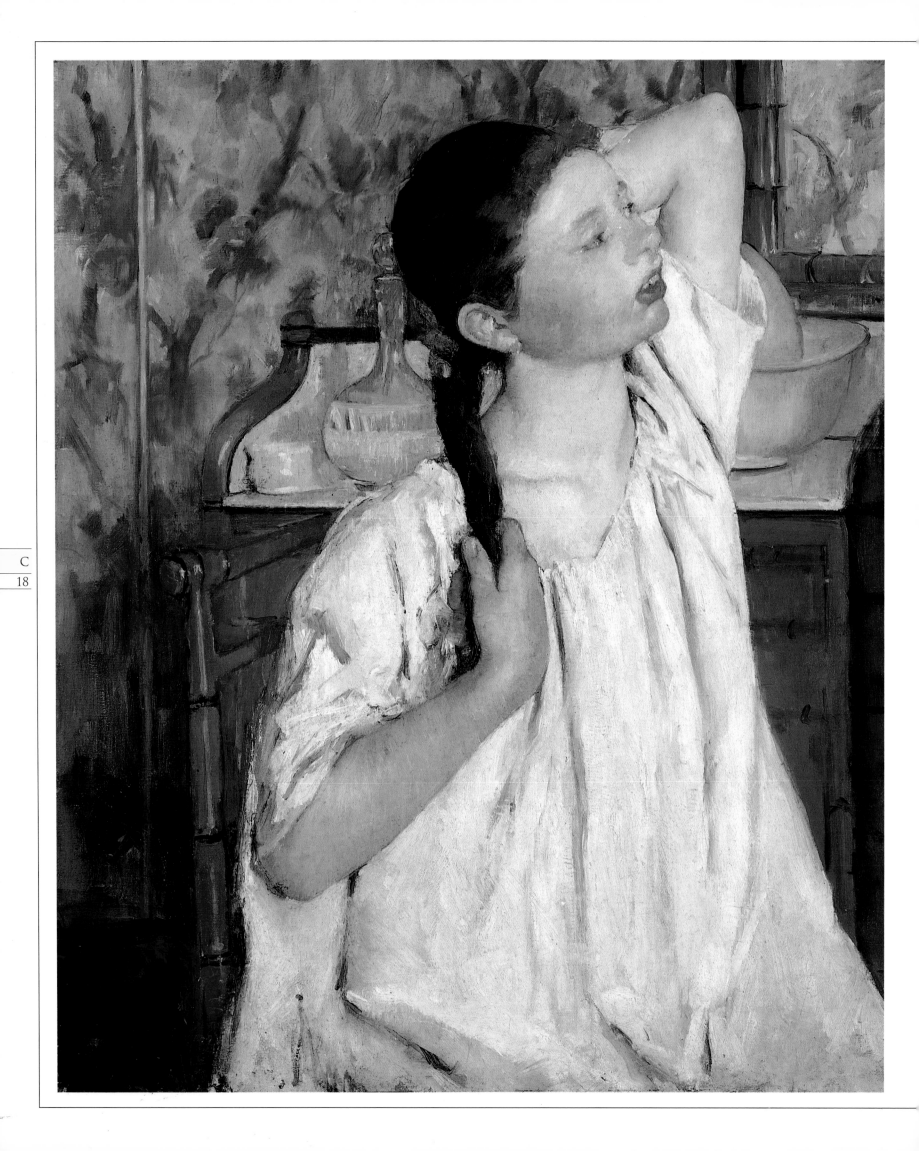

CASSATT, MARY
1844–1926 b. US, active France

GIRL ARRANGING HER HAIR

AS A WEALTHY AMERICAN SPINSTER, Mary Cassatt was the most unlikely of the Impressionists. Yet, because of the implacability of her eye and the certainty of her sense of form, even Degas was forced to recognize, however unwillingly, that she was an equal. *Girl Arranging her Hair* is an extraordinary painting for the 19th century. It completely disregards any attempt at the picturesque or romantic, and eschews a sense of narrative. For once, we are not asked to ponder on the mental workings of this young woman – on her love life or its absence – but to look at the truthfulness of the painting. The firmness of that flushed face, with its mouth too full of teeth, and the practical braid of her hair are entrancing in their very freedom from romanticism. The simplicity of the wash table behind her, with its curving basin and water jug, and the chair – rather uneasy in its perspective – that frames the girl with a vertical to match the table's, all cause us to see this girl in her voluminous night smock as innocent and springlike.

CASSATT'S PAINTINGS *have a warm solidity that will not let us encounter them without a genuine confrontation. The surprising thing about this work is that its composition is so appealing in itself we become unaware that the girl herself may not be. It has been said that Cassatt once claimed she could paint an attractive picture of an unattractive person, which is, after all, almost a definition of art.*

GIRL ARRANGING HER HAIR
*1886, oil on canvas, 30 x 25 in
(75 x 62 cm), National Gallery
of Art, Washington, DC*

MOTHER ABOUT TO WASH HER SLEEPY CHILD
1880, oil on canvas, 39 x 26 in (100 x 66 cm), Los Angeles County Museum

Although Cassatt herself apparently never wanted marriage and children, many of her paintings deal with these most womanly of relationships. She has a special gift for understanding the intimacy between mother and child, and the happy, relaxed sprawl of this baby on its mother's knee is unusual in art. The baby's leg dangles between the mother's, while the maternal hand rests casually in the water, as if about to pick up the cloth and wipe the child's sleepy face. This is painted by an artist who has looked long and often at babies and mothers and who can show uncomplicated affection with immense skill.

CÉZANNE, PAUL 1839–1906 b. France
THE LARGE BATHERS

FOR CÉZANNE, THE IMAGE OF NAKED BATHERS in a wood had an ambiguous fascination. It recalled his boyhood, the one time in which he seems to have been unreservedly happy; and yet he was also drawn by the idea that the perfect woodland idyll would not be composed of young men, but of young women – woodland nymphs. Cézanne seems to have feared women; they were a mystery to him. He never painted from a naked model, but sought out photographs from which he assembled his compositions. His passion for truthfulness, to show the world as it really was, reached its culmination in the challenge that the bathers set him: to give an idea of blissful permanency while recognizing with equal force that nothing in nature is permanent, that change is encoded in the very genes of creatures who live under the dominion of time. For years I could make no sense of the bathers; they seemed so unappealing compared to the radiance of Cézanne's landscapes and still lifes. But gradually they have come to seem, to me, the greatest of his works, the strongest and, strangely, the most beautiful. If one abstracts from the actual lumpiness of the bodies, then that gleaming flesh dappled by shade – with all the burden it bears of Cézanne's hopes and fears – has an unforgettable poignancy.

THE TREES BEND IN *to enclose these vulnerable bodies with a frail protection, while the river guards them from behind. Yet, across the divide are those two strange and unreadable figures who seem to represent another world – a world on which the bathers, literally, turn their backs.*

AT FIRST, THE BATHERS *are immensely off-putting – large, awkward, and unconvincing – but they have a strange majesty. There is a courage and a neediness about the bathers that makes them the most emotional, and perhaps the most powerful, of all that this great artist painted.*

THE LARGE BATHERS
*1899–1906, oil on canvas,
82 x 98 in (208 x 249 cm),
Philadelphia Museum of Art*

CÉZANNE, PAUL
STILL LIFE WITH APPLES AND ORANGES

WHAT CÉZANNE LOVED about a still life was that he could control it. Whereas a hillside changed constantly under the shadows of the clouds, his still life stayed there for him to master it. In a strange way he sees the still life as a minor landscape: the great cascades of the cloth, the towering forms of the jug and the bowl, all have a grandeur that makes us aware that we are looking at more than what appears. He blithely ignores perspective, tilting his planes in a way that would, of course, be impossible in real life, so that we can take in the full scale of what is displayed on the table – a device that Picasso and the Cubists were later to take up, and turn almost inside-out.

*"I am the
primitive of
a new art.
I shall have
my successors;
I can
sense it"*

Paul Cézanne

STILL LIFE WITH
APPLES AND ORANGES
*c.1895–1900, oil on canvas, 29 x 37 in
(74 x 93 cm), Musée d'Orsay, Paris*

COX, DAVID 1783–1859 b. England
THE CHALLENGE

THROUGH TURNER, Victorian artists learned to value
the sublime – the wild, unleashed power of nature.
For David Cox, however, the forces of nature had
meaning primarily as an inescapable part of a
laborer's life; he was himself a blacksmith's son and
his origins were deep in the countryside. Three years
before he died, Cox painted *The Challenge: A Bull in a
Storm on a Moor*. Here we see the wild surgings of
nature, and the desperate attempts of an animal to
stand up to the adversity of its current conditions.
This blind courage, doomed and yet noble, may well
have a personal significance for Cox, for he seems
to empathize entirely with this animal's plight.

THE CHALLENGE: A BULL
IN A STORM ON A MOOR
*c.1856, watercolor and gouache
on paper, 18 x 26 in (46 x 67 cm),
Victoria & Albert Museum, London*

DEGAS, EDGAR 1834–1917 b. France
THE TUB

MANY GREAT WORKS OF ART depend upon the artist's emotional involvement in the subject matter. This is not true of Degas. It is his lack of involvement, his ability to stand back from the subject, his skill at seeing animate or inanimate objects and human or non-human forms as simple shapes, that gives his art an edge. His compositions are conceived as if peering through a keyhole, especially when he paints one of his favorite themes – women washing. It is well documented that Degas regarded women's bodies as not fully human, but it is this lack of humanity in his representation of the female form that sets him free. He focuses instead on the curve of the body and on the way light falls on the form. He delights in shapes – the tub in which she squats – before cutting obliquely across the canvas to the line of the table top.

THE TUB *is a strangely intimate picture, almost embarrassing in its closeness, but at the same time awe-inspiring in the way the artist's eye perceives the subject. Degas controls his world view with such elegance that he can take the reality and incoherence of life and build it without omission or illusion into a powerful image.*

THE TUB
*1886, pastel on paper,
24 x 33 in (60 x 83 cm),
Musée d'Orsay, Paris*

DEGAS, EDGAR
MELANCHOLY

MELANCHOLY IS AN UNUSUAL PICTURE for Degas. Atypically, he focuses on emotion rather than form outlined by color. This woman is not merely an animal shape, it is her sadness, her suffering that has attracted the artist. Typical of Degas, he conveys this inertia as clearly in her body posture as in her facial expression; no artist ever understood body language more intuitively than Degas.

" *[Degas] loved, he said, to paint as if "through the keyhole," catching his subjects when they thought themselves unobserved* "

MELANCHOLY
c.1874, oil on canvas,
7 x 10 in (19 x 25 cm),
Phillips Collection, Washington, DC

> **"By the means of a simple nude I wanted to suggest a certain barbaric luxury of ancient times"**
>
> Paul Gauguin

GAUGUIN, PAUL 1848–1903 b. France
NEVERMORE

IT IS HARD TO UNDERSTAND Gauguin's art without being aware of the extraordinary journey he undertook to the South Seas, which he felt compelled to take to escape conservative Paris and his wife and children (who struggled in great poverty thereafter). Gauguin fled to the wild romance of the Tahitian islands to live as a creative bachelor in the sunshine. This longing for a distant paradise colored all of his work as did this need to escape from the constraints and commitments of life and find an impossible fulfilment in the never-never world of sun, pleasure, and free love. Like all human beings,

Gauguin pursued his romantic ideals at a cost. By the time he painted *Nevermore,* he had come to realize that the South Seas were not his for the taking. His nubile young mistress gave him her body, seen here in its gleaming green-gold beauty, but her spirit would evade him forever. The girl lays her head on the glorious buttercup-yellow of her pillow, but her eyes are narrowed with fear and suspicion. This was an exotic world that Gauguin could only inhabit at a superficial level, and this painting is a lament for his exclusion.

THE TWO WOMEN *whispering together in the background add to the tension. We feel, as perhaps Gauguin did himself, that something is going on behind the scenes – something dark and frightening, against which the girl is unprotected.*

THE PICTURE'S ENIGMATIC *title, Nevermore, alludes to Edgar Allan Poe's poem "The Raven." Here, the weird strutting figure of a bird looms at the center left of the painting. This is perhaps the South Seas version of a raven, colored and slightly contorted, but, for Gauguin, it is still very much a bird of ill omen.*

NEVERMORE
1897, oil on canvas, 24 x 46 in (61 x 116 cm), Courtauld Institute Galleries, London

GAUGUIN, PAUL
THE MEAL

THE MEAL WAS PAINTED in the year in which Gauguin deserted his family. The children depicted here may be an unconscious recollection of his own children. They sit before a richly laden table, which is too high for them, and wait dejectedly for food that does not come. Outside, we see golden sands, and sunlight hits the front edge of the table; yet, as one moves into the picture, the considerable sense of sadness deepens. *The Meal* shows, perhaps, the essential contradiction at the heart of Gauguin's psyche: the urge to create art at any cost and, yet, a conscious unwillingness to accept how his life decision took its toll on others.

G
32

" *Gauguin impresses his own version of nature upon us, creating stylized, flattened shapes and using intense, exotic colors with what seems like reckless abandon* "

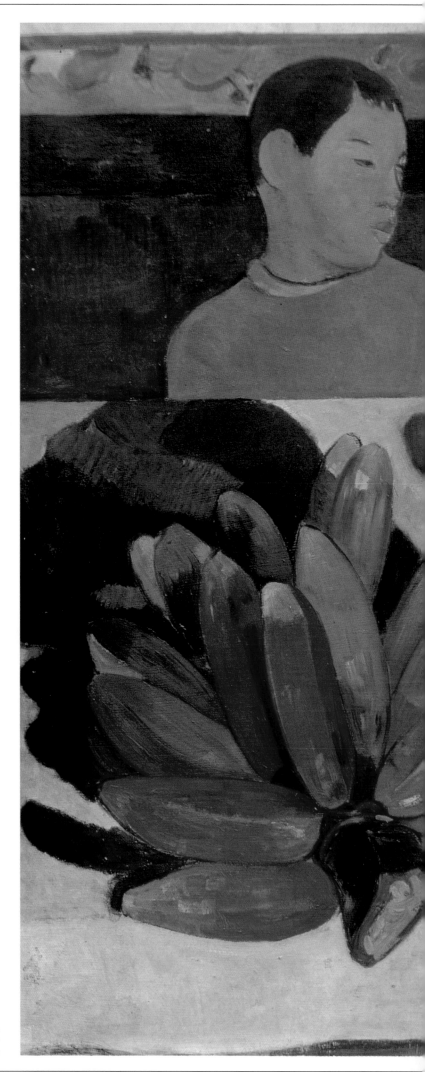

THE MEAL
1891, oil on canvas, 29 x 36 in
(73 x 92 cm), Musée d'Orsay, Paris

GOGH, VINCENT VAN 1853–90 b. Netherlands

PEACH BLOSSOM
IN THE CRAU

VAN GOGH IS PROBABLY the best loved of all artists, partly
for the sheer power of his work and partly for the pathos
of his story. The two, of course, are not unconnected. His
work derives its power from the intense frustration of his
loneliness and from his inability to find those who would
love his work and buy it. Everything van Gogh paints
seems a receptacle for an ever-increasing psychic urgency. In
itself, *Peach Blossom in the Crau* is an extraordinarily beautiful
landscape, but it is a landscape made so quiveringly alive
by the artist's intensity that it transcends all description and
becomes something greater than artifice, something held on
the canvas only by an immense psychic pressure.

THE BLOSSOMS *are not
allowed to fill up their world.
Beyond them stretch bare
fields, with the closed houses
pressed down by their roofs,
and, beyond that, the ridge of
mountains hemming in the
world. A dense and speckled
sky – each paint mark visible
– presses down upon the scene.*

VAN GOGH *used painting
as a way to find a precarious
mental balance, and his
raging insecurities, focused,
channelled, and given visible
expression, are what make
his paintings unique. They
are, in a most moving sense,
variations of self-portraiture.*

PEACH BLOSSOM
IN THE CRAU
*1889, oil on canvas,
26 x 32 in (65 x 81 cm),
Courtauld Institute
Galleries, London*

Gogh, Vincent van
Self-Portrait

IF EVEN A LANDSCAPE IS REPRESENTATIVE of van Gogh the man, what are we to make of a genuine self-portrait? The sense of conflict and encroaching madness, controlled with the utmost intensity, is almost overpowering here. The world behind the artist whirls and is kept at bay only by the sharp outline of the figure; within that outline, the same frightening tumult threatens, again, to overwhelm the painter. But the wild strokes are forced by the artist to cohere into a meaningful pattern.

SELF-PORTRAIT
1889, oil on canvas, 26 x 21 in
(65 x 54 cm), Musée du Louvre, Paris

" *To make us see through his eyes is the triumph of the artist, and van Gogh triumphs often* **"**

JOHN, GWEN 1876–1939 b. England
GIRL HOLDING A ROSE

A GWEN JOHN IS UNMISTAKABLE; there is what one can only describe as a tentative certainty in her paintings. Within them, we can perhaps sense a defeat that still will not surrender, but which forces the artist against her fear of failure into producing gentle, yet astonishing, images. *Girl Holding a Rose* is astonishing in more ways than one. The sad, beautiful, introspective face could seem wholly realistic, but then one notices the misalignment of the shoulders and the peculiar elongations of the body. It is as though John was stretching her out like plasticine and molding her in rough paint, with a desire more to make visible the presence of this young woman and the impact she made upon the artist than to depict the actual lines of her figure and the outward appearance of her form.

JOHN'S DESIRE *to convey to us the presence of her friend has led her to structure the body almost like a giant pyramid, with an enormous base that almost fills the width of the canvas, tapering up through the thick arms to the final clarity of the domed head.*

THE LARGE *clumsy hands seem almost indistinguishable from the rose. This is not a trophy rose – the flower has no function outside the folded and melancholy fingers. Around the young woman rise the vaguely adumbrated walls of an interior, luminous and glowing with a comforting sense of enclosure and protection.*

INTERIOR (RUE TERRE NEUVE)
c.1920s, oil on canvas, 9 x 11 in (22 x 27 cm), City Art Galleries, Manchester, UK

Gwen John painted from the reality of her own private life. Again and again she dwelt upon the features of her friends and the intimacies of her own surroundings. She was always poor, so this is a poor attic home, yet it is made lovely by the sunlight. The table dazzles under its brightness, and all we can distinguish with complete clarity is that very British-looking teapot. Perhaps significantly, in the view of her deepening commitment to religion, the window seems to resemble a crucifix. Whatever its austerity, this is clearly a refuge in which the artist delighted.

GIRL HOLDING A ROSE
c.1910–20, oil on canvas, 18 x 15 in (45 x 37 cm), Paul Mellon Collection, Yale Center for British Art, New Haven, CT

OLYMPIA
1863, oil on canvas, 51 x 75 in (130.5 x 190 cm),
Musée d'Orsay, Paris

MANET, ÉDOUARD 1832–83 b. France
OLYMPIA

THIS WAS THE PAINTING with which Manet shocked the art establishment of Second Empire Paris. They were accustomed to the female nude, but always in a setting that made it innocuous; it was a goddess, or a symbol, or an allegory – never in the brutally honest form with which most adult males were secretly accustomed. Manet confronts, head-on, the hypocrisy of his times, which refused to admit to the presence and the fascination of the prostitute. Olympia herself, clearly, feels no need for disguise. She rears herself up on her pillows, those glorious white-gray pillows that Manet explored with sensuous delight, and looks straight and challengingly at the customer who is entering. He may have thought to have sweetened his approach with the glorious bouquet that the maid holds up for her attention, but Olympia ignores it. Like the round-eyed kitten with erect tail, Olympia is ready to challenge the client who comes in ostensibly as her superior. Her small and witty feet, the magnolia in her hair, the air of a grand lady at leisure, all combine to make this one of the most delightful of paintings.

THE TRUE GLORY of the picture is in the color: we see the dark-brown of the maid contrasted with the darkness of the curtains, the inky black of the kitten against the whites of the sheets, the pinky-lemon of Olympia against that glorious oriental shawl, and it is hard for us to understand how anybody could have failed to respond.

THE FIFER
1866, oil on canvas,
63 x 39 in
(160 x 98 cm),
Musée d'Orsay, Paris

MANET, ÉDOUARD
THE FIFER

THIS SMALL CHILD, eyes looking inward as he concentrates on his music, is almost a cut-out set in an indeterminate space into which the clarities of military life do not completely fit. Manet never painted with more stringent reduction of what he saw to its strong and beautiful basics.

MONET, CLAUDE 1840–1926 b. France

THE PETIT BRAS OF THE SEINE AT ARGENTEUIL

THE IMPRESSIONISTS WANTED, above all, to give us an impression of a particular moment in time, of a particular light and mood, to give the feeling of what it was like to be somewhere specific. The greatest of the Impressionists is Monet, and in this picture we see him in an uncharacteristically gentle mood. We are standing with him on the banks of a narrow stretch of river that glimmers away into the distance. It is a scene absolutely without drama. Nothing is happening except for the silent activity of those two small, black figures on the near side. And yet, each element of the scene – the great pure, pale sky; the trees barely leafed, the sandy banks without even the allure of grass – combines to create a feeling of the utmost tranquillity. Monet's genius is in taking a scene that, in actuality, we might well have passed by without a glance and dwelling on it long enough to make us aware of the wonder of this privileged moment.

> **" *Monet is only an eye, but my God what an eye* "**
>
> Paul Cézanne

THE PETIT BRAS OF THE
SEINE AT ARGENTEUIL
*1872, oil on canvas, 21 x 28 in
(53 x 72 cm), National Gallery, London*

MONET, CLAUDE
THE JAPANESE BRIDGE

MONET'S EYES DIMMED as he aged, which had a strangely wonderful artistic consequence. Knowing the theme of this work – that it is the bridge over his Japanese pool – we can just make out the bridge and the waters and the foliage, and understand that the glorious scarlet comes from the setting sun. And yet, without the title, might we not have thought that this was an abstract painting?

> **"** *Monet is the quintessential Impressionist, and as such his world is exhilaratingly beautiful* **"**

THE JAPANESE BRIDGE
*1918–24, oil on canvas, 35 x 39 in
(89 x 100 cm), Musée Marmottan, Paris*

THE CONSTRAINTS *that curve around in the foreground and angle at the back are barriers that set the waters free, and it may be that Morisot saw here an emblem of her own need for self-control, without which her artistic powers would be lost.*

MORISOT, BERTHE 1841–95 b. France
THE HARBOR AT LORIENT

BERTHE MORISOT WAS an upper-class young
woman who, without any obvious necessity to
paint other than for her own enjoyment, turned
out to have a genuine artistic talent, comparable
to many of the best Impressionists. She married
Manet's brother and was inevitably borne into
the sphere of that family's influence. *The Harbor
at Lorient* seems to me to be head and shoulders
above all her other work. Here, she achieves
a solidity, a power, and a ravishing sense
of atmosphere that owes less to the stylistic
influence of the Impressionists and more to
her own innate visual ability. This is her sunlit
world – a world of order and precision and clear
bright color. Morisot feels completely at home
here, and the picture draws us into its depths.

THE HARBOR AT LORIENT
*1869, oil on canvas,
17 x 29 in (44 x 73 cm),
National Gallery of Art,
Washington, DC*

THE LADY SITTING COYLY *on the harbor wall with her pink
parasol directs us back into the vast glimmer of the blue waters,
above which are the harborside buildings and the ships and the
great sky that arches over all.*

IN THE DINING ROOM

This picture provides a fascinating insight into Morisot's strengths and weaknesses. The one solid figure is the maid – solid, at least in her face, hands, and body (although even her apron is drawn into the swirling and tremulous chaos of the material world that surrounds her). Morisot was both drawn to the tremulous and indecisive and repelled by it. Her weakest works give way to the fluttering beauty of vagary and whim; her strongest works affirm the power of her personality. Here we see both, as the maid emerges all the stronger in her control of the indeterminate looseness of her context.

"Morisot learned from Manet how to catch the passing hour and make it stay for her, how to render the exquisite delicacy of light without hardening it into what it is not"

IN THE DINING ROOM
*1886, oil on canvas, 24 x 20 in
(61 x 50 cm), National Gallery
of Art, Washington, DC*

" *[Munch] used all his psychic weakness to create electrifying art* **"**

MUNCH, EDVARD 1863–1944 b. Norway
THE SICK CHILD

As HIS ART LEADS US TO EXPECT, Munch had a shadowed childhood. First, his mother died, and then his elder sister suffered a protracted and painful death. Munch's father was a doctor, and it was when he accompanied him on visits to the sick that Munch felt sufficiently distanced from his own experience of death and grieving to create his own images of sickness and despair. The child stricken by illness and her anguished mother constitute almost an icon of human helplessness, and Munch was temperamentally receptive to such despair. The sad mourning of life and hope is very visible in this tragic painting. The girl is painted in the lurid colors of fever, her red hair in sickly contrast to the unhealthy gleam of her pallid skin. Her bodily form is a mere outline as she leans against the cruel brightness of the bedhead, with its pathetic attempts at decoration. It is the mother – that great, black, bowed image of grief – who bears the implacable message that the child has no certain future. The work is saved from melodrama by Munch's insight into early death; he does not paint as a spectator here, but as one who knows what it means to grieve hopelessly.

ALTHOUGH MUNCH *presses us up against the foot of the bed, we are protected from the full impact of infected breath by the cabinet on one side, with its seemingly useless bottle of medicine, and by the bedside table on the other, upon which sits a half-empty, and equally futile, drinking glass.*

THE CONSTANT VERTICALS *pressing downward, the lack of any clear definition except that of wood and glass, the feverish unhealthy and unearthly color, all spell out a message of funereal gloom. But if we can stand back from the narrative of* The Sick Child *and look at the picture objectively, these strange slashes of color have a weird beauty peculiar to themselves.*

THE SICK CHILD
1885–86, oil on canvas,
18½ x 18½ in (47 x 47 cm),
National Gallery, Oslo

PISSARRO, CAMILLE

1830–1903 b. West Indies, active France

THE CLIMBING PATH, L'HERMITAGE, PONTOISE

FOR MOST OF HIS LIFE Pissarro was too poor to travel very widely in search of motifs, but it also seems to have been congenial to his domestic temperament that he should take great pleasure in painting his own environment. It was when he had moved to the village of Pontoise on the River Oise, just to the northwest of Paris, that he embarked on a series of magnificent landscapes. *The Climbing Path, L'Hermitage, Pontoise*, is a picture of extraordinary daring. What has seized the artist's attention as he climbs the steep hill is not just the view but the actual path that continues its way precipitously upward. Pissarro's sense of composition, the necessity to integrate all the elements, is so intelligent and deep-rooted that looking at this double vision, as it were, we never feel that what we see is a painting in two parts. The winding sunlit path is echoed by the sunlit walls on the left, by the sunlit trees, and by the grass, shimmering and golden in the distant fields and close by at the bottom left.

LITTLE TOUCHES *orchestrate the painting so that we can fully believe in this great swooping view that descends from the pink wall and the trees in the foreground to the meadows below. The distant white house and the three poplars, framed by a gap in the trees, balance the curve of the ascending path.*

PISSARRO *gives us a sense of movement, carrying the eye up and out of the picture. The view is delightful and, while it lacks drama, there is a profound beauty in its colors and shapes. It is this, together with the hint of intrigue as the path leads out of the canvas, that makes this an early masterwork.*

"*Pissarro tended to stray in and out of pure Impressionism as the spirit took him, unconcerned with the rigors of style***"**

THE CLIMBING PATH,
L'HERMITAGE, PONTOISE
*1875, oil on canvas,
21 x 26 in (54 x 65 cm),
Brooklyn Museum of Art, New York*

PISSARRO, CAMILLE
VIEW FROM LOUVECIENNES

BEFORE HIS MOVE to Pontoise, Pissarro lived in another village near Paris, this time seemingly much flatter. Yet, here again, he makes pure poetry out of a road. Another artist, less of an Impressionist, might have seized upon the ruin on the distant hill; but Pissarro's genius is to take what is ordinary and unimposing, and paint it with such truth and love that we see its beauty. This insignificant road glows in the sunlight with such serenity that one envies the artist and is grateful that he should share with us his experience.

" Pissarro's paintings, with their almost naive simplicity and unpolished surface, influenced Gauguin, van Gogh, and Cézanne, who called himself the "pupil of Pissarro." "

VIEW FROM LOUVECIENNES
1869–70, oil on canvas, 21 x 32 in
(53 x 82 cm), National Gallery, London

C. Pissarro

RENOIR, PIERRE-AUGUSTE 1841–1919 b. France
THE GUST OF WIND

SAY TO PEOPLE the name Renoir and frequently the image that springs to mind is that of the solid and voluptuous nude basking in the sunlight. Renoir did indeed have a special interest in the naked female – perhaps something of his vigorous spirit responded to the challenge – but here is Renoir at his most tender and sensitive. Looking at this picture, one is immediately aware of the young man who walked across a field one morning and suddenly saw the trees quiver under the impact of a gust of wind. He communicates to us most vividly and perceptibly how nature shivers for the moment as the wind ruffles the grasses, sways the trees, and seems to be reflected in the uncertainties of the white clouds and blue sky. It is as if, while we look, shapes move and sway. He paints a blur that is almost imperceptible and yet wholly real. We believe in this moment – this ordinary, but intensely realized, experience of one man at one moment over a hundred years ago.

> *" Renoir seems to have had the enviable ability to see anything as potentially of interest "*

THE GUST OF WIND
*c.1872, oil on canvas,
20 x 32 in (52 x 82 cm),
Fitzwilliam Museum, Cambridge, UK*

IT IS BECAUSE of Renoir that grass will always quiver and the trees will always sway. The gust of wind (by its very nature, passing and uncontrollable) has been miraculously held, not statically but in motion – that most challenging of art's possibilities.

EVEN THE SHAPE of the hillside seems to reform itself under our eyes, as the wind sweeps over it. The horizon dips and rises in an almost oceanic motion and the swirls of the grass, seemingly pulled by the power of the wind, are echoed by the clouds, scattered and scuffed across the blue of the sky.

A. Renoir. 74.

RENOIR, PIERRE-AUGUSTE
THE PARISIENNE

RENOIR TOOK INTENSE PLEASURE in naked female flesh, yet his greatest works, like The Parisienne, are of clothed women. Here, he captures the essence of the young woman of Paris – her stylishness, her modish hat, the flirtatious exuberance of her curl, and the gown that both clings to her body and bursts out into the absurd bustle. All the defenses of modesty are maintained, and yet the soft form within those great swathes of blue is made perfectly clear.

THE PARISIENNE
1874, oil on canvas,
63 x 41 in (160 x 105 cm),
National Museum of Wales, Cardiff

" *Renoir was particularly entranced by people* "

SARGENT, JOHN SINGER 1856–1925 b. US
THE DAUGHTERS
OF EDWARD D. BOIT

SARGENT HAD A WEALTH OF IMAGINATION AND INVENTION that is often undervalued. Commissioned to paint the four daughters of the wealthy Edward D. Boit family, the artist seems to have intuited something about the family relationships that called for this extraordinary composition. It is impossible to know whether he deliberately posed the four girls like this, or whether it was by their own choice, but one feels that, either way, it was in response to some emotional truth. It certainly was by his choice that they were set in this great, cavernous room, which swallowed them up in its immensities and made them seem homeless in their own home. Disunited without, one feels, a niche or a nest, they are clearly seen by Sargent as poor little rich girls; they seem lost, children without a place, without a space. There appears to be little love between them, perhaps little love for them, and they are evidently irritated by the presence of the artist. One hesitates to call it a dysfunctional family, but this is a cold, unwelcoming environment for four young women. They are dwarfed by the enormous Chinese vases, expensive objects that are clearly valued and cherished, as the daughters in their drab pinafores do not seem to be. Even the baby of the family, too young to respond to the invisible currents of family politics, sits in isolation.

> **"** *At his best, Sargent could be as ruthless as Goya, and with something of his technical brilliance* **"**

MRS EDWARD D. BOIT
1888, oil on canvas, 60 x 43 in
(153 x 109 cm), Museum of Fine Arts, Boston

Mrs Edward D. Boit (the former Mary Louisa Cushing) was the mother of the four girls whom Sargent had painted earlier. We do not feel that she welcomed her painting – she is putting on a face, tilting her head to encounter the artist. Her dress has the expected magnificence, as does the chair, but Sargent does not gloss over her double chin, her long nose, or her irregular teeth, and he makes a delicious nonsense of her ludicrous head attire.

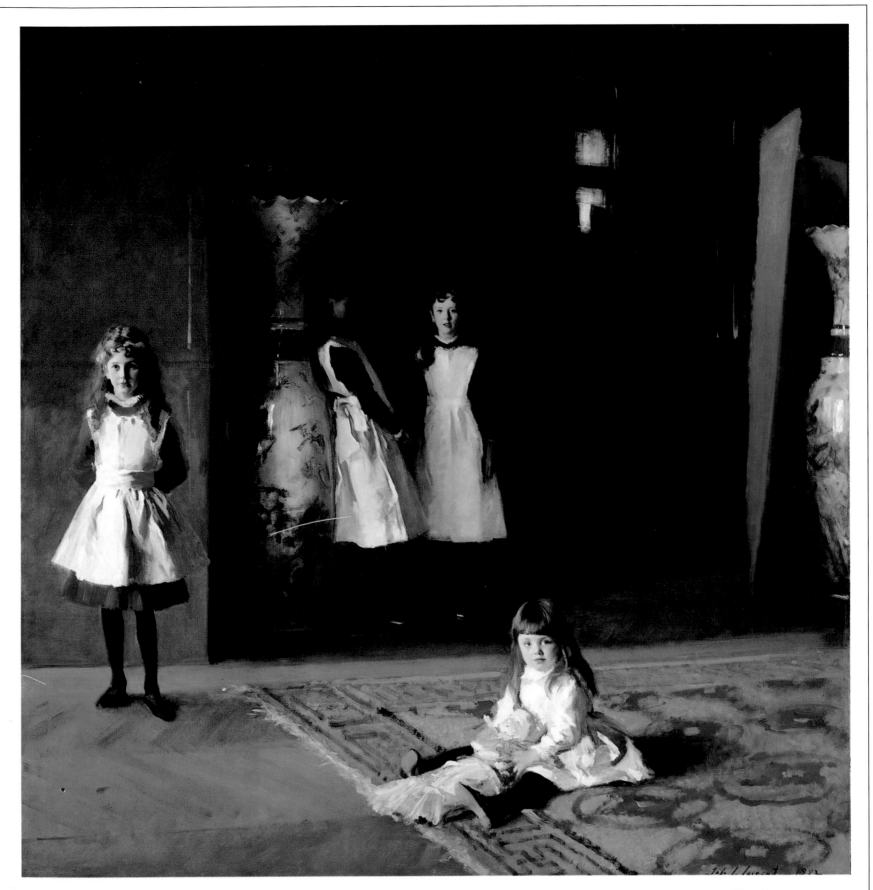

THE ELDEST DAUGHTER *sullenly disassociates herself from the portrait. She stands in the shadows, and we can catch her face only dimly. Daughter number two does not quite have the courage to withdraw herself, but she presents a blank face.*

DAUGHTER NUMBER THREE *is happy to stand, isolated but at least fully in the light, and confronts the artist with a degree of implacable attention – one feels that this is a young woman to be reckoned with. The youngest merely looks with interest at the amusing man brought in to entertain them.*

THE DAUGHTERS
OF EDWARD D. BOIT
*1882, oil on canvas,
87 x 87 in (221 x 221 cm),
Museum of Fine Arts, Boston*

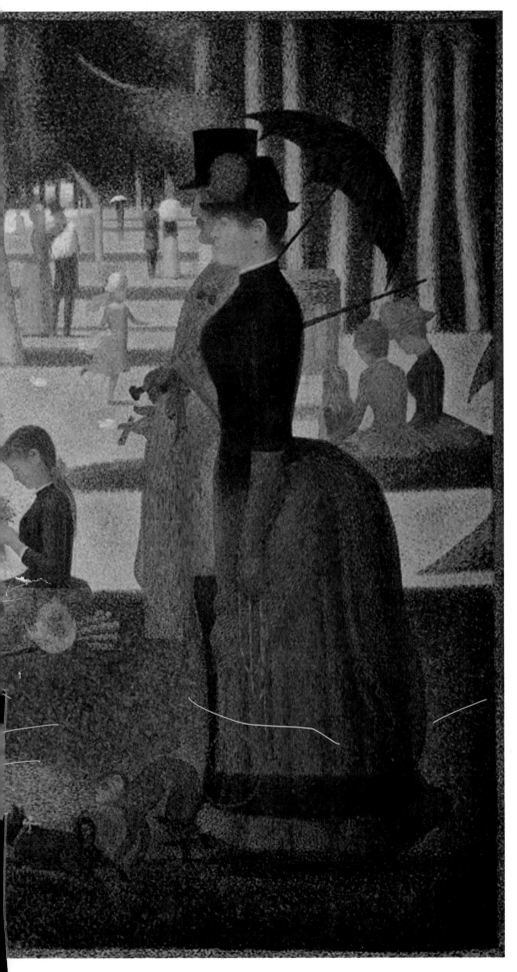

SEURAT, GEORGES 1859–91 b. France
LA GRANDE JATTE

IT IS HARD TO BELIEVE THAT SEURAT was barely 31 when he died. His work has such maturity that it seems the product of a resolved old age, rather than the first fruits of a young genius. Seurat believed that the discoveries of the scientists, especially in the area of optics, were vitally important to the artist, and Seurat made great use of them. His own theory, called Pointillism or Divisionism, was based upon the idea that we see, physically, in terms of small quivering dots of color, which within the eye are transformed into the solidity of the image. *A Sunday Afternoon on the Island of La Grande Jatte* shows what Seurat accomplished with the security given to him by these theories. He has taken a commonplace Parisian scene and rethought it in terms of architectonic majesty. Everything here has a grandeur and a simplicity that makes it almost awesome. He has looked at, and visually grasped, each person; he has taken contemporary life and transmuted it; it has been rethought in a parallel dimension, and given an eternal stability, a dignity that seems, not imposed, but innate.

THERE IS SOMETHING *strange and unnatural about the scene of Parisians at their leisure, a frozen element that Seurat did not desire. Yet, it is this very immobility, in its solemnity and grandeur, that makes this luminous canvas one of the great achievements of the 20th century.*

A SUNDAY AFTERNOON ON THE ISLAND OF LA GRANDE JATTE, *1884–86, oil on canvas, 81 x 120 in (206 x 305 cm), The Art Institute of Chicago*

SEURAT, GEORGES
PORT OF GRAVELINES CHANNEL

SEURAT HAD ONLY A YEAR TO LIVE when he painted this
majestic work. Already he was beginning to reject the
restrictions of Divisionism. The dots are far larger here, far
freer, yet the scene seems like a slice of eternity. This may
well have been exactly what he saw: promenade, channel,
ships, and sky. Yet, this essentially unimpressive view is
held forever in an inner light of its own making. It gleams
before us under the quiet weight of material existence.

" *Seurat's
landscapes have
an interior quiet
that prevails
magnificently
over natural
confusion* **"**

PORT OF GRAVELINES CHANNEL
*1890, oil on canvas,
29 x 37 in (74 x 94 cm),
Indianapolis Museum of Art*

SICKERT, WALTER RICHARD

1860-1942 b. Germany, active England

LA HOLLANDAISE

IN DISCUSSIONS that attempt to pin down the greatest British painter of the 20th century, the name of Sickert always arises. His was a strange, passionate genius, able at times to subdue itself to the more domestic interests of Victorian life and other times determined, as it were, to push further, to peel back the facade, and to show what the novelist Joseph Conrad referred to as "the heart of darkness." A contemporary murder of a prostitute, which resulted in a long and enthralling court case, gave focus to Sickert's imaginings. Many of his portraits of prostitutes, as here, have a dark undertone; one can imagine these women being brutalized or even killed. He shows the Dutch girl with her face in the shadows – who she is is hidden behind what she does. What she does is made brutally clear: she is framed by her iron bed and the light falls on her breast and thigh. Sickert was a dark painter, but he coaxed miracles of subtlety from his subdued palette, and the sheer visual excitement of *La Hollandaise* is hard to beat.

LA HOLLANDAISE
*c.1906, oil on canvas, 20 x 16 in
(51 x 40 cm), Tate Gallery, London*

THE RAISING OF LAZARUS
*c.1930, oil on wallpaper on canvas, 96 x 36 in (244 x 92 cm),
Art Gallery of South Australia, Adelaide*

This is an image so daring that it is difficult to read. We do not associate Sickert with religious painting, and yet we are aware of sacred exhilaration as the long body of Lazarus, still wrapped in its gleaming shroud, is nurtured back to life. The uppermost figure is tenderly freeing the dead man's face. The blacks and greens suggest the lividity of death, with the hope of new life coming at the bottom of the picture in gleams of pink flesh. The very indistinctness of the image – its capacity to confuse and bewilder us – gives it a strange power.

SIGNAC, PAUL 1863–1935 b. France

GAS TANKS AT CLICHY

SIGNAC SEEMS TO HAVE BEEN bowled over by one great artistic principle, which he followed with growing intensity all his life. The principle was that of Divisionism, or Pointillism – a semi-scientific theory that proffered that painting in the form of colored dots would cohere before the eye into an image that was more beautiful and impressive than paintings produced by more conventional means. Here, in his early twenties, we see Signac beginning to grasp the implications of this transcendent principle. *Gas Tanks at Clichy* could hardly be less enticing as a title, and yet Signac makes of it a wholly splendid picture. He displays to the full that chromatic diversity and integrity that he felt was the overriding glory of divisionism. The dots here are not small and the divisions are barely visible, but he has spotted the canvas with his colors in an almost abstract way. From this pattern of dots, a wonderful image of sand and grasslands has emerged.

S
70

THE GREAT TANKS *on either side, beyond the small dwelling, recall the majesty of the Colosseum. But it is less the architecture that is so exciting here than the way Signac uses color: the wall on the left, for example, is dappled with pinks and blues as if every stone were catching a different light and reflecting a different aspect of the building before it.*

WE ARE HELD *at a distance from the gas tanks and the central block. They are fenced off from us, and to get there we traverse this great extent of sand and rough vegetation. Signac is still experimenting with his new discovery, but what he does with it is already wonderful and exciting, and he conveys a sense of the infinite possibilities of the creative world, whether man-made or divine.*

GAS TANKS AT CLICHY
1886, oil on canvas, 26 x 32 in (65 x 81 cm), National Gallery of Victoria, Melbourne

Signac, Paul
Port of Concarneau

Here, forty years after painting the gas tanks, Signac's divisionism is more ardent, but now the method has taken over. We seem to be looking not at nature expressed through a certain artistic lens but at nature transformed into a mosaic, with little pretence at realism. If one is to see nature as a series of small colored squares, then this work could hardly be bettered. The sky glimmers with the kaleidoscopic purity of variegated color, and the ships have an almost oriental luxuriance as they sail through the bright waters.

PORT OF CONCARNEAU
1925, oil on canvas,
29 x 21 in (73 x 54 cm),
Bridgestone Museum of Art, Tokyo

SISLEY, ALFRED 1839–99 b. France
WOMEN GOING TO THE WOODS

WHEN SISLEY PAINTED *Women Going to the Woods*, he was a wealthy man in his late twenties, who was able to paint for pure pleasure; later, his family was to lose its money, greatly changing his prospects. It remains surprising that he was consistently unsuccessful. To us, he seems one of the most beautiful of the Impressionists. Even here, in this early work there is a solidity and a power in his painting that any artist would envy. The three women in the center serve to anchor the scene, standing on that wonderful sunlit path that leads past us into the mystery of the woods. But there is sufficient mystery in the village itself. The eye dwells with rapture on that dull, green meadow running down to the stone wall beside the shuttered house, so clear in the brilliance of this early morning. The village is shuttered – no doors are open and no windows visible – and there is a sense of the refugee about each of the women who huddle together to set about their work.

" *Sisley's paintings are some of the most subtly beautiful of the Impressionists, and they are heavenly in their peaceful celebration of nature* "

PERHAPS AS A PAINTER *of an art that was unappreciated, Sisley felt rejected. If so, his revenge was to look at that bleak, unwelcoming surface and paint it as supremely beautiful, not needing the support of a brilliant palette, or even the glory of bright sunlight to give interest. There is a sober maturity here that is astonishing.*

WOMEN GOING TO THE WOODS
1866, oil on canvas, 26 x 36 in (65 x 92 cm),
Bridgestone Museum, Tokyo

SISLEY, ALFRED
FLOODS AT PORT MARLY

In 1876, the River Seine overflowed its banks and flooded the village of Port Marly. Sisley painted the scene of devastation. Tragedy rarely attracted the Impressionists, and what Sisley has actually seen is not the human cost but the natural beauty. He has shown only how the little village is improved by the floods, turning it into a miniature Venice, with light catching on the water. An air of the world set free from its constraints permeates this work.

FLOODS AT PORT MARLY
1876, oil on canvas, 24 x 32 in
(60 x 81 cm), Musée d'Orsay, Paris

STEER, PHILIP WILSON 1860–1942 b. England

GIRLS RUNNING, WALBERSWICK PIER

IN TERMS OF TECHNIQUE this is an interesting painting, but it is its weird visionary quality that makes this picture so extraordinary. Against the blue and white of the sea, two girls float toward us, two sprites almost dematerialized by light. The ostensibly banal theme of girls running along a pier has become portentous for Steer, yet without the least touch of the pretentious. The girls seem to merely skim the surface, holding their hands out as if to bear them aloft, while the three women in the background, equally slender and ethereal in appearance, are solidly anchored to the wood on which they stand. There is an angelic element to the girls running. Why do they run? It does not seem to be a race and the artist gives no indication of a goal. Their faces are impassive. They share both real and ethereal worlds in that their shadows link them firmly to the more solid figures in the background, yet they themselves seem to be escaping from the confines of earth.

GIRLS RUNNING,
WALBERSWICK PIER
*c.1888–94, oil on canvas, 27 x 37 in
(69 x 93 cm), Tate Gallery, London*

TOULOUSE-LAUTREC, HENRI DE 1864–1901 b. France

THE CLOWN CHAU-U-KAO

THE FEMALE CLOWN Chau-U-Kao was a frequent model for Toulouse-Lautrec, and one suspects that what attracted him was her ability to make fun of her own imperfections. Toulouse-Lautrec, as the last descendant of an ancient French family, must have been bitterly conscious of his own physical deformities, and to many people he, too, was a figure of fun. Chau-U-Kao's name meant, apparently, noise and chaos, because she was laughed and hooted at – something to which Lautrec, who was

impatient of the civilities of aristocratic life, felt attracted. He shows us Chau-U-Kao preparing for her act with dignity and serenity, the great swirl of her frill seems to bracket the clown so that we can truly look at her, see the pathos of that blowsy and sagging flesh, and move on to the nobility of the nose and the intense eyes. This is a degradation, but one that has been chosen by the performer and redeemed by intelligence and will power.

TOULOUSE–LAUTREC is the great artist of the poster, and even in his oils one can see that outlining, that clarity, that simplicity of form – the attributes of a good poster designed to be seen from a distance. With his wonderful eye for a graphic line, Lautrec angles out Chau-U-Kao's arm, directing our attention with the foolishly dangling yellow ribbon in her topknot.

WE SEE THE CLOWN in her dressing room where the blue and yellow of the stippled walls and blurry red of her settee clash and rebound off the shock of her costume. She is buttoning herself up into an overtight purple dress, the whole of which is surrounded and surmounted by that extraordinary gaudy yellow frill.

THE CLOWN CHAU-U-KAO
1895, oil on cardboard, 25 x 19 in (64 x 49 cm), Musée d'Orsay, Paris

CHAU-U-KAO based her act upon her superabundance of flesh, deliberately setting herself up to be laughed at. Lautrec is showing us that, despite her ludicrous appearance, here is a serious performer who chooses to use herself as an object of ridicule and accepts the financial advantages of this. The parallel here, between the clown and the artist, is poignant.

Toulouse-Lautrec, Henri de
WOMAN LYING ON HER BACK

As an outsider to his own society, Lautrec felt most at home with those other outsiders: prostitutes. The brothel was the one area where he was accepted and made welcome. He was bitterly conscious of the tragedy of these women's lives, their need to pretend, to exploit themselves, the lack of any of the natural pleasures that make most lives tolerable. Here, he shows a prostitute in one of her rare moments of solitude. She has no customer; there are no calls on her. She collapses onto her workplace – her bed – her slim legs in their black stockings inelegantly sprawled, and luxuriates in the pleasure of being alone. Lautrec uses a quick and sketchy line to suggest the febrile and unstable nature of the woman's life.

" *Lautrec's art is characterized by a self-assured simplicity of line, dramatic color, and flat shape* "

WOMAN LYING
ON HER BACK
1896, oil on board,
12 x 16 in (31 x 40 cm),
Musée d'Orsay, Paris

TUKE, HENRY SCOTT 1858–1929 b. England

GIRL WITH A PITCHER

TUKE IS NOT A HOUSEHOLD NAME, but this British painter is noted for his images of the sea with naked boys bathing. *Girl with a Pitcher*, however, was painted early in his career; before he launched himself into what was to become a lifelong obsession with seascapes. It is a remarkably honest painting for the period. Tuke painted the girl, who would probably have been a fisherman's wife or daughter, in Cornwall. He makes no attempt to romanticize the girl, as he was to do later with his sunlit boys; instead,

he captures her weariness and her wiry fragility. Her dark eyes peer out at us accusingly from the cramped doorway of her dungeon-like home, where only a small window is open to the light. The sophistication of Tuke's later work has none of the rough honesty that we see here; the paint is actually visible on the crude walls. For Tuke, it is not who the woman was but how she looked that stopped him in his tracks, made him stand full in her face, and sketch her poverty-stricken existence as he encountered it.

GIRL WITH
A PITCHER
1884, oil on wood,
13 x 8 in (34 x 20 cm).
David Messum
Gallery, London

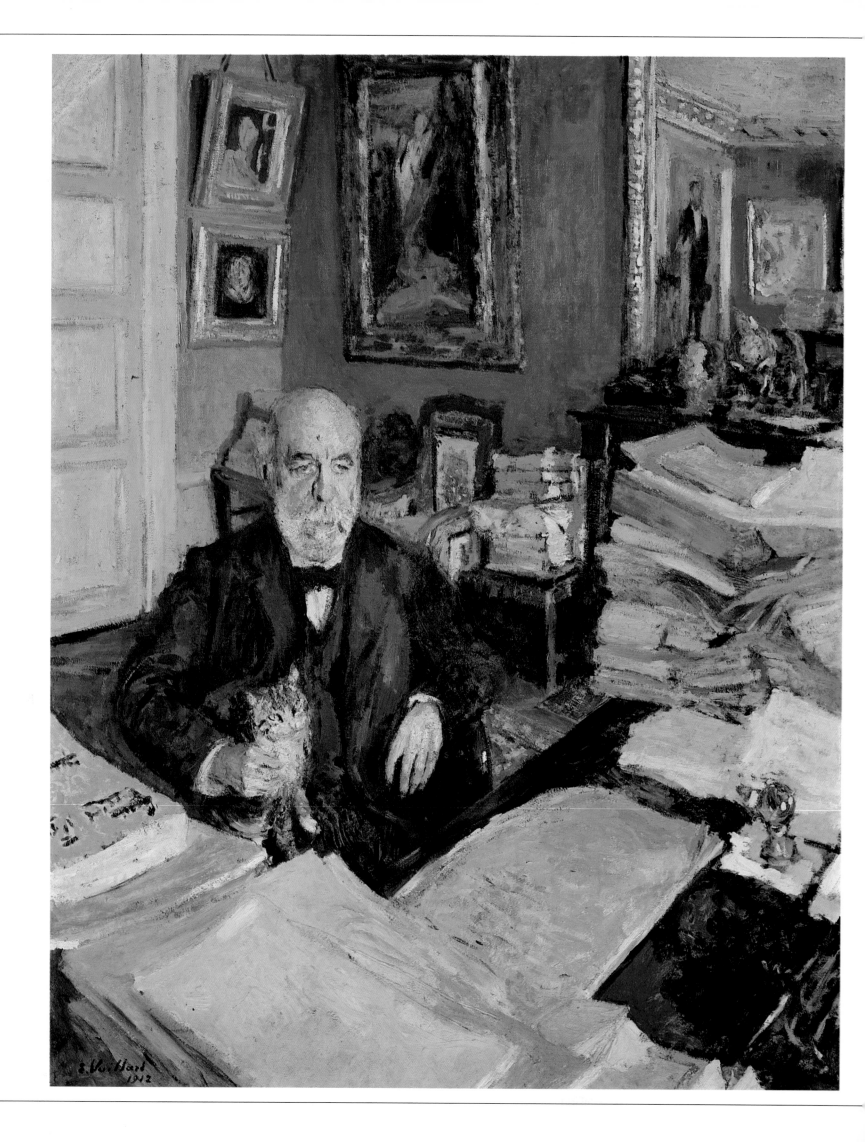

VUILLARD, ÉDOUARD 1868–1940 b. France
PORTRAIT OF THÉODORE DURET

VUILLARD IS THE GREAT PAINTER of interiors and since the interiors of his youth were Victorian, he was supremely at home with the idea of clutter. He had lived in a household of women, with his mother and sister, who were busy dressmakers, and an awareness of the fabrics flung over all the surfaces and the constantly changing patterns stayed with him all his adult life. Here, he paints Théodore Duret, an art critic who had understood and championed the Impressionists. Duret sits almost imprisoned in the chaos of his study. On all sides we see evidence of his enthusiasms. The room encloses him, but it does so in a radiance of color, shape, and pattern. It is a supremely decorative picture – decoration not overwhelming the solid bulk of the sitter but complementing him, suggesting the richness of his inner life and the multiplicity, even in old age, of his interests.

THE CAT LOOKS UP *at the artist as if aware of his presence, whereas Duret sinks into himself – lost in reveries of the past. Here is an old scholar, at least that is how Vuillard wishes us to see Duret. In actuality, he was more of an art critic and a dealer, but Vuillard certainly wishes to convey the idea of Duret the scholar, with his books and catalogs stacked high.*

REFLECTED IN THE MIRROR *over the mantelpiece is Whistler's portrait of Duret in his youth – a young opera-goer with a top hat in his hand and a woman's cloak draped over his arm. Vuillard is making an affectionate contrast between that vibrant young man, active in society, with this old scholar, sitting wearily at his empty desk with no companion but his cat.*

❝ [Vuillard] is less interested in coloristic fireworks than in the gentle, muted subtleties of texture ❞

PORTRAIT OF THÉODORE DURET, *1912, oil on cardboard, 37 x 29½ in (95 x 75 cm), National Gallery of Art, Washington, DC*

VUILLARD, ÉDOUARD
MOTHER
AND CHILD

THE CHARMING CLUTTER of this small
room is typical of Vuillard. It is almost
an abstract pattern in which we have
to search out the human beings from
among the glorious diversity of shapes
and colors and intricate forms – where
the figures themselves are subsumed into
that pattern. There is the young mother
and the round, rosy head of her baby,
and, behind on the bed, two small
dogs. Vuillard's genius is to convey
the intimacy of this little scene and
yet maintain as the focus of his
interest its decorative quality.

MOTHER AND CHILD
c.1899, oil on cardboard,
19 x 22 in (49 x 57 cm),
Glasgow Museum and Art Gallery

WHISTLER, JAMES 1834–1903 b. US

HARMONY IN GRAY AND GREEN: MISS CICELY ALEXANDER

HAVING YOUR PORTRAIT painted by Whistler was not easy. He was a perfectionist and demanded hours upon hours of patient sitting or, in this case, standing. We can understand why young Cicely has a rather disgruntled expression, but it was worth the wait; this is a superb illustration of the fragility and sweetness of youth. Cicely is as fresh and delicate as the daisies springing up at her side, and like them she must accept the ravages of time. The same fragility of beauty is symbolized by Whistler's favorite motif of the butterfly (they hover above Cicely's head, and his famous "butterfly" signature can be seen on the back wall). The brightest color in the picture is her face, with those rosy, pouting, and unhappy lips. All else seems to float upon the canvas: whites, grays, blacks, so subtle, so nuanced that they seem to dissolve and reform themselves before our very eyes. Perhaps "infinity" – infinitely beautiful, infinitely graceful, infinitely vulnerable – is the word that best sums up this picture.

"Whistler is at his best when he plays with shapes and colors and it is their intrinsic interaction that delights him, rather than the play of light itself"

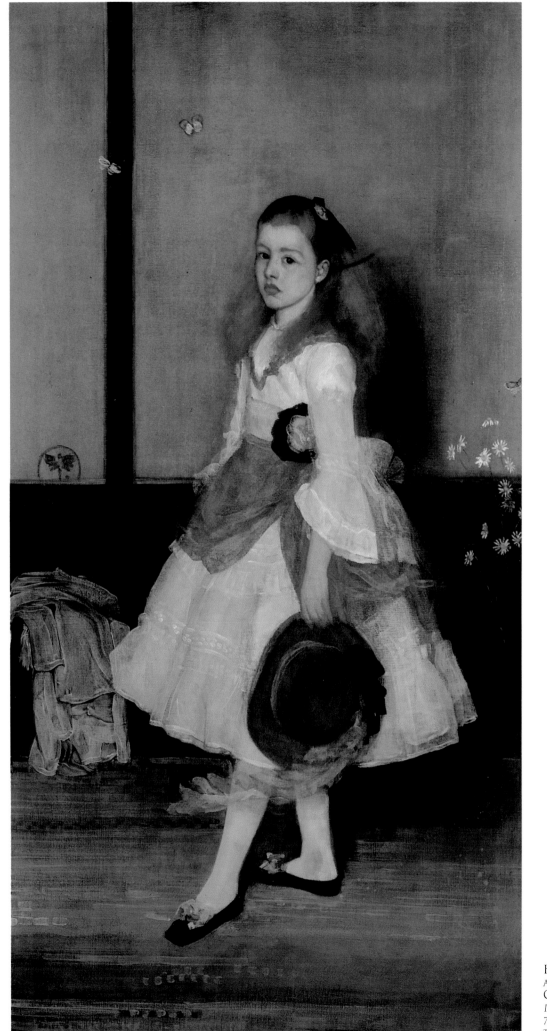

HARMONY IN GRAY
AND GREEN: MISS
CICELY ALEXANDER
1872–74, oil on canvas,
75 x 39 in (190 x 98 cm),
Tate Gallery, London

WHISTLER, JAMES
NOCTURNE: BLUE AND GOLD

WHISTLER FELT AN AFFINITY WITH THE MUSIC of Frédéric Chopin and was convinced that the magical effects of Chopin's Nocturnes could be paralleled in paint. Here, around the form of old Battersea Bridge, is an efflorescence of golden fireworks and the scattered golden lights of misty London. We are meant to be affected, not by the details of the work, but by its whole harmony, to be moved as we are by music.

NOCTURNE: BLUE AND GOLD
*1872–77, oil on canvas, 27 x 20 in
(68 x 51 cm), Tate Gallery, London*

W
93

DIRECTORY OF MUSEUMS AND GALLERIES

ART GALLERY OF SOUTH AUSTRALIA
North Terrace, Adelaide SA 5000
Tel: +61 8 8207 7000
http://www.artgallery.sa.gov.au

Walter Sickert: *The Raising of Lazarus*

ART INSTITUTE OF CHICAGO
111 South Michigan Avenue, Chicago, Illinois 6063-6110
Tel: 312-443-3600
http://www.artic.edu/aic/

Eugène Boudin: *Approaching Storm;* Gustave Caillebotte: *Rue de Paris, Wet Weather;* Georges Seurat: *A Sunday Afternoon on the Island of La Grande Jatte*

BROOKLYN MUSEUM OF ART, NEW YORK
200 Eastern Parkway, Brooklyn, NY 11238-6052
Tel: 718-638-5000
http://www.brooklynart.org/

Camille Pissarro: *The Climbing Path, L'Hermitage, Pontoise*

CARNEGIE MUSEUM OF ART, PITTSBURGH
4400 Forbes Avenue, Pittsburgh, PA 15213-4080
Tel: 412-622-5563
http://www.cmoa.org/

Pierre Bonnard: *Nude in Bathtub*

LOS ANGELES COUNTY MUSEUM OF MODERN ART
5905 Wilshire Boulevard, Los Angeles, California 90036
Tel: 323-857-4787
http://www.lacma.org/

Mary Cassatt: *Mother About to Wash her Sleepy Child*

MUSEUM OF FINE ARTS, BOSTON
295 Huntington Avenue, Boston, Massachusetts 02115-4401
http://www.mfa.org/

John Singer Sargent: *The Daughters of Edward D. Boit; Mrs Edward D. Boit*

NATIONAL GALLERY OF ART, WASHINGTON
National Gallery of Art, Washington, DC 20565
Tel: 202-737-4215
http://www.nga.gov/home.htm

Mary Cassatt: *Girl Arranging her Hair;* Berthe Morisot: *The Harbor at Lorient; The Dining Room,* Edouard Vuillard: *Théodore Duret*

NATIONAL GALLERY, OSLO
Universitetsgaten 13, 0164 Oslo, Norway
Tel: +47 22 20 04 04
http://www.museumsnett.no

Edvard Munch: *The Sick Child*

NATIONAL GALLERY OF VICTORIA, MELBOURNE, AUSTRALIA
P.O. Box 7259 Melbourne VIC 8004
Tel: +61 3 9208 0222
http://www.ngv.vic.gov.au

Paul Signac: *Gas Tanks at Clichy*

NATIONAL MUSEUMS & GALLERIES OF WALES
National Museum & Gallery, Cardiff
Cathays Park, Cardiff CF10 3NP
Tel: +44 (0)2920 3977951

Pierre-Auguste Renoir: *The Parisienne*

MANCHESTER CITY ART GALLERIES, UK
Room 1025, Town Hall, Albert Square, Manchester, M60 2LA
Tel. +44 (0)161 236 5244
http://www.cityartgalleries.org.uk

Gwen John: *Interior (Rue Terre Neuve)*

MUSÉE D' ORSAY, PARIS
62, rue de Lille, 75343 Paris, cedex 07, France
Tel: +33 1 40 49 48 14
http://www.musee-orsay.fr

Gustave Caillebotte: *Self Portrait;* Edgar Degas: *The Tub;* Paul Gauguin: *The Meal;* Vincent van Gogh: *Self Portrait;* Edouard Manet: *Olympia; The Fifer;* Alfred Sisley: *Floods at Port Marly;* Henri de Toulouse-Lautrec: *The Clown Cha-U-Kao.*

MUSÉE NATIONAL D'ART MODERNE, PARIS
Centre National D'Art et de Culture Georges Pompidou
75191 Paris cedex 04, France
Tel: +33 1 44 78 12 33
http://www.centrepompidou.fr

Pierre Bonnard: *The Almond Tree in Blossom*

NATIONAL GALLERY, LONDON
Trafalgar Square, London, WC2N 5DN
Tel: +44 (0)20-7747 2885
http://www.nationalgallery.org.uk

Eugène Boudin: *The Beach at Tourgéville-les-Sablons;* Claude Monet: *The Petit Bras of the Seine at Argenteuil;* Camille Pissarro: *View From Louveciennes*

TATE GALLERY, LONDON
Millbank, London SW1P 4RG
Tel: +44 (0)207-887 8869
http://www.tate.org.uk/

Walter Richard Sickert: *La Hollandaise;* Philip Wilson Steer: *Girls Running, Walberswick Pier;* James Whistler: *Harmony in Gray and Green; Miss Cicely Alexander; Nocturne: Blue and Gold*

INDEX

PICTURE CREDITS